Bernard Leach

Drawings
Verse
& Belief

Bernard Leach

ONEWORLD

DRAWINGS, VERSE & BELIEF

Oneworld Publications Ltd
1c Standbrook House, Old Bond St, London W1X 3TD

© Bernard Leach 1973, 1977, 1988
All rights reserved. Copyright under Berne Convention
First published 1973.
Second revised edition published 1977
Third revised, enlarged edition published 1988
by Oneworld Publications

British Library Cataloguing in Publication Data
Leach, Bernard
Drawings, Verse & Belief – 3rd rev., enl. ed.
I. Title
821'. 914 PR6062.E

ISBN 1-85168-012-8

Photographs of the author © 1988 Paul Slaughter

Designed by Rodney Mylius

Printed in Great Britain by
Butler & Tanner Ltd, Frome and London

DEDICATION

This book is dedicated to my friend Mark Tobey
the American artist who introduced me to the Bahá'í Faith.

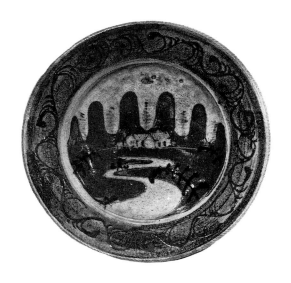

Introduction

'If you had your life to live all over again, what would you change?'

This question was put to Bernard Leach during the last year of his life. His instantaneous reply: 'Nothing, except myself, I hope'.

'A change for the better?'

'Of course. Deeper, wiser, truer, more loving. When I went into hospital nine years ago and very nearly died, what did I learn? That I had never been as kind as those who were kind to me. And I felt shame at myself for not having been more thoughtful, more kind, more generous. It did make a difference.'

The life and work of this great Englishman – artist, potter, writer and thinker – spanned the continents of Europe and Asia. Born in Hong Kong on January 5th, 1887, the son of a colonial judge, his childhood years were spent in Japan, Hong Kong and Singapore. At the age of ten he was sent to England to continue his education, and at sixteen he enrolled at the Slade School of Art which was, for Leach, 'sheer joy.' He had found his vocation, and life began to take on new meaning. A year later, when his father consulted Henry

Tonks, his teacher, about his future, he replied that although Leach was still too young for an accurate assessment, he could not advise him to allow his son to become an artist! This resulted in Leach spending a somewhat unhappy year working in a museum and in banking, before returning to his first love of art and two terms at the London School of Art. In 1909 Bernard Leach returned to Japan with the first etching press ever to reach that country, planning to make a living teaching etching and at the same time study Eastern art and culture.

Two years later he was to experience a dramatic change to the course of his life when he attended a *raku yaki* tea-party with a group of artists and writers, and first saw *raku* pots being made. He recalled: 'One was taken out from the kiln, red hot, with long-handled tongs, dipped into a bucket of cold water, and it did not break. I thought, "Isn't it exciting! I want to do that; I believe I could learn to do that. I wonder if I could get a teacher?" I did.' Fired with enthusiasm, he apprenticed himself to the sixth generation of Japanese potters working in the tradition of Ogata Kenzan (1663–1743), who was a noted maker of *raku* ware. Together with Tomimoto Kenkichi (1886–1963), Leach earned the prestigious title of Kenzan VII, denoting the seventh generation of Kenzan potters.

In 1920 Leach returned to England and, with the help of his friend the great Japanese potter Hamada Shōji (1894–1978), he established his celebrated pottery in St. Ives, Cornwall. On his arrival, he had been immediately appalled by the low standard of commercial ceramics: 'At a conservative estimate, about nine-tenths of the industrial pottery produced in England . . . is hopelessly bad both in form and decoration.' Having learned the craft of pottery in a country barely touched by industrialisation, his primary concern was to make well-designed functional pots which everyone could afford, re-establishing a standard of quality which industrialisation had destroyed. His own work was a blend of classical oriental pottery (Chinese, Korean, Japanese) and traditional pre-industrial slipware. Leach saw his Anglo-Orientalism as an artistic bridge between two distinct cultures, East and West, and his work had a profound effect on the studio pottery movement in Britain, of which he was considered to be both its father-figure and most celebrated

practitioner. Students and followers were attracted to his studio from all over the world, and through his many travels throughout his life his work also made an important contribution to the development of pottery in Japan and elsewhere.

During the twenty-one years Bernard Leach lived in the Far East he developed a great respect for the art, culture and religion of its peoples which deeply influenced his work and beliefs. 'My own work as a potter and draughtsman,' he wrote, 'was inextricably becoming rooted in two hemispheres and I began to find myself in the position of a courier between East and West'. He spoke fluent Japanese and over the years made many friends, becoming known not only as a gifted artist-craftsman but for his spiritual perception of Japanese values. As he prepared to leave Japan in 1920 some of his friends presented him with a book entitled *An English Artist in Japan*, in which Soetsu Yanagi, art critic and founder of the Japanese Craft Movement, wrote of him:

> When he leaves us we shall have lost the one man who knows Japan on its spiritual side . . . I consider his position in Japan, and also his mission in his own country, to be pregnant with the deepest meaning. He is trying to knit the East and West together by art, and it seems likely that he will be remembered as the first to accomplish as an artist what for so long mankind has been dreaming of bringing about.

It was in Japan, in the early days of the First World War, that he first heard of the Bahá'í Faith. Over the following years, in the course of his work and frequent travels, an uneasy agnosticism gave way to the conviction that art, in its striving for truth and beauty, is one with religion. First-hand experience of Buddhist thought and life in Japan, followed by many years of close involvement with inter-religious ideas and conversations, had, as he put it, 'widened my mind'. His close friendship with the American artist Mark Tobey, whom he first met at Dartington Hall in the early thirties, resulted in a period of study and inner search which several years later led him to accept the Bahá'í Faith – a religion whose very basis is the unity,

3

not only of East and West, but of the whole world of humanity. So important was this faith to him that he could claim it was, 'inherent in my thoughts whether written, drawn or tucked away in the background of my pots'.

Although Bernard Leach enjoyed worldwide fame as a potter and received many distinctions, he never wanted to be put on a pedestal; his great humility was one of his most notable and endearing qualities. 'When you're young it's difficult to get rid of the ego – it wants to see the shine and the colour of butterfly wings', he said in an interview with the Monterey Peninsula Herald in 1979. 'But as you get older you are gradually freed of pride.' The blindness which in the latter years of his life prevented him continuing his gifted work as a craftsman and artist he accepted with philosophic acquiescence: 'Losing outer sight, I gained far greater inner vision.' The spiritual awareness which grew with his blindness was an inspiration to visitors who came from far and wide to see him, and is the focus of many of the verses in this volume. After his long years of study, work, teaching, writing and travels, he felt he could leave this world with all work done. 'Death as a friend, death as a doorway' he wrote to a friend in the last year of his life.

Bernard Leach's artistic and cultural work won him distinguished awards. In 1962 he was made a Commander of the Order of the British Empire for his contribution to the development of British pottery. In 1966, for his cultural services to Japan, he received the Order of the Sacred Treasure, Second Class, the highest honour the Japanese Government bestows on a foreigner. In 1970 he was honoured by the World Crafts Council at a gathering in Dublin, and in 1973, in a private audience with Her Majesty Queen Elizabeth at Buckingham Palace, he became the first craftsman ever to be made a Companion of Honour. In 1974 he received the Japan Foundation Cultural Award. The centenary of his birth, 1987, was commemorated in Britain by the issue of a special set of postage stamps in his honour.

Bernard Leach died in 1979, at the age of ninety-two. He has been referred to as 'the greatest artist-potter-writer of this age', and 'perhaps one of the greatest men of our time'.

Belief

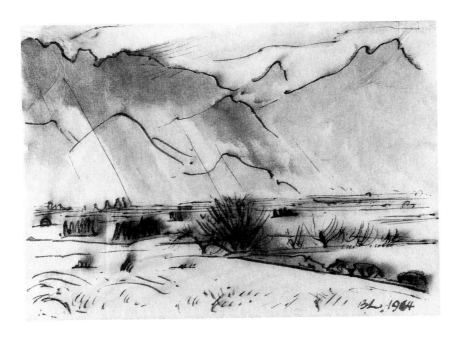

I have drawn since I was six years old and always wanted to be an artist. At sixteen I was sent to the Slade under Henry Tonks, who, having once been a good surgeon, duly carved me up with his scalpel. Once he said, 'You may be able to draw some day'. I am grateful to him and also, later on, to Sir Frank Brangwyn, who taught me how to etch. One day, in my second term, he said suddenly, 'How long have you been in art schools?' 'This is my fifth term altogether', I answered. 'Get out', he said, 'Go to nature'. I got out – to Japan – where four years of my early childhood had been spent. I went under the influence of that half-Irish, half-Greek stylist, Lafcadio Hearn, to try to understand Eastern art and the culture in the background of its peoples. I little knew how long it would take, but have never regretted my intuitive decision for a moment.

It took years of surprise to find out how unlike Eastern man was to Western, and the rest of a lifetime, or most of it, to discover the unfamiliar common groundwork of humanity in search of truth and beauty. Certainly life in Japan made me a captive to nature, and I have remained so ever since, not leaning by training towards that cool abstract which has seized the mind of mechanized man. Nevertheless it was in nature-loving Japan that I first, by what appeared to be sheer chance, saw *raku* pots being decorated and fired before my eyes. There and then I was indeed seized, not only by a determination to take up the craft, but was inevitably drawn into a field of abstract art, albeit one more organic and less mechanical. During the interval between then in 1911 and 1920 when I returned home to England, friendship with young and older Japanese began to open the doors of perception. In the fifty-three years since then I have revisited Japan nine times and work has also taken me to many other parts of the world.

As far back as 1913 it began to become apparent how that which we call fate lay behind my original intuition to return to the East where I was born (Hong Kong). My own work as a potter and draughtsman was inextricably becoming rooted in two hemispheres and I began to find myself in the position of a courier between East and West. By one way or another I bore witness to a growing vision of a future unity of mankind. Agnosticism of many years' standing gave way to an expanding faith in the maturity of man on this planet.

Clearly some people found evidence of this growth in my silent pots and drawings, especially in Japan, where a cleavage between fine and applied art is regarded as absurd. In Japan, moreover, there existed no suspicious opposition to an artist expressing himself in more than one medium or direction, any more than it existed during the European Renaissance. Thus it was that when the mood, the thoughts, the very words came to me, almost unbidden, asking for expression, for which I could not find an outlet in pots and drawings, I did not hesitate to put them down in such prose as a brief education allowed, or even in verse. For many years I hardly showed the latter to a soul. In versification I had no training whatsoever, though there have always been poets whom I have loved. I had even introduced Blake and Whitman to my friend Dr. Yanagi, the founder

of the Japanese Craft Movement, who presented both to the Japanese public by means of a magazine called *Blake and Whitman*. Of course, in the poetic field I feel diffident and an amateur, but so I do as a potter and draughtsman, and so does Hamada, who had more training than I had. Not long since he said to me 'Any thrower on the potter's wheel in my town of Mashiko is more skilful than I am'. This simply means that skill may be merely professional, which in itself is no guarantee of art – the spirit may be lacking. I am content with just adequate skill to embody living thought. If my two lines:

> *The sheep are nibbling the grass*
> *On Romney Marsh*

is an imperfect rhyme, so too is Blake's:

> *Priests in black gowns*
> *Are walking their rounds.*

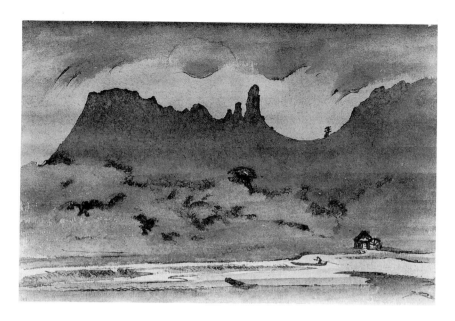

The point is, I feel I have, like him, a message to deliver concerning something much more important than myself and my shortcomings. I mean the beliefs, the arts and their successful cultural interplay between the two hemispheres. Without doubt I have slowly accumulated convictions concerning the meaning of Life itself – beauty as a proof of truth, for example, or the mirage of the self in the face of Infinity – which interpenetrate at least a third of my verses and which many would call philosophic or religious. So be it. After forty years wandering in the byways of agnosticism I have found through belief the beginnings of a bridge connecting East and West. If by truth in any of my life's work I can contribute a single brick to its building I shall be well content.

Those of my drawings chosen for this book are mostly landscapes, and a few portraits. In them there is little or no direct religious influence. However, this is unnecessary from my point of view, because no real work of art can fail to strive for truth and beauty, and consequently, to the extent to which it succeeds, it is inevitably religious. Undoubtedly influences are there, mostly below the level of consciousness – from oriental painting and calligraphy – the touch – the accent – the bone – the significant empty spaces –

asymmetry, etc. These qualities contribute to fuller life in art and work, and the acceptance of them from the East is a sign-manual of fast-growing orbital thought.

Ever since my early twenties in Japan I have been increasingly aware of that which is loosely called East and West. Early on I thought of it as an opposition, later I came to see the relationship as complementary. We in the West had what they in the East needed, and vice versa. The vision of a great exchange in the future emerged, not only between Europe and Asia, but also between North and South in other continents – a total human climax of international understanding, justice and peace. I was driven to this conclusion not primarily by theory, but through my own experience in art, born of the life which surrounded me. The vastness and unlikelihood of so great a development shook me into deeper consideration of the unforeseeable changes which have taken place in the past, even in our lifetimes. Doubtless art is the flower of the tree of life, an epitome of the joyful significance of beauty as prelude to the fruit by which a tree is judged and its continuity assured.

Whence the seed of Life? How was that core, that belief about the meaning of Life – Jewish, Hindu, Buddhist, or Muslim – conceived through the millennia of human history? How could an Eastern-born Westerner coming from England hope to understand Eastern culture without facing such fundamental issues? How could I not be influenced by Eastern art in picture, pot or poetry? If art, then too its matrix of belief. How could I equate my own inheritance of Christianity with Buddhism?

Art, as we endeavour towards perfection, is one with religion, and this fact is better recognized in the East. Perfection is more like the state prior to the expulsion from the Garden of Eden than the mere opposite to imperfection. The oriental concept of Life or, as we would say, God, is non-dualistic at root, and this is difficult for our Western rationalism. If, as Genesis declares, 'He made us in His own likeness', then we have overlooked the responsibilities attendant upon the freedom of choice to refuse Him until we rediscover, usually painfully, Reality.

In the same way as that in which the ultimate inscrutability of the 'I am that I am' holds us, so do these words contain their own verity.

We, 'made in His image', have within us a power to recognize truth when we meet it. From ancient India comes the sanskrit, 'Tat tvam asi' (That thou art). Everything that exists is an infinitesimal part of Totality – Buddhism does not speak of God but of 'Thusness' (Things as they really are). I am convinced that these three roots about the meaning of life are not in conflict. All from West to furthest East are unitive and not dualistic. Our dualism commenced when we separated intellect and intuition, the head from the heart, and man from God.

Scientific discovery in the Western world has, through radio, television and fast air travel, brought about a sudden change in the speed of evolution and a greater division in human personality. At the same time the immense power hidden in the tiny atom has been discovered and released. The horror of stockpiling hydrogen bombs freezes the heart of mankind because their use could decimate life on earth. Two world wars 'to end war' have taught us nothing but increased fear, which may control behaviour for a time, but does not change the heart or bring about unity. For the sake of peace and understanding among men the Christ has lived and died again and again.

A man was born at the close of one era and the beginning of another, whose concept of inclusive unity gave so powerful a voice as to eventually force me out of my persistent doubt. His name was Bahá'u'lláh (the Glory of God). Born in Persia in 1817, he died in Palestine in 1892 after forty years in prison, whence his fuller revelation emanated. For the first time a divine Genius could speak to mankind during the greatest crisis in history. This is the 'time of the end' (of an epoch), when men may comprehend that which Jesus said they could not comprehend in his day. Instead of a diminution of the concept of God to nullity is its expansion to man's united wholeness. How else can we understand each other or hope for peace? A genius has intuitive knowledge in art or science; a divine genius has it of God's relationship with man, and, as a man himself, of our relationship with God. At last it dawned upon me that such a divine genius had come again, just as Christ and Muhammad had foretold.

The difficulty I experienced in accepting the Bahá'í Faith lay in the apparent curtain hung between normal man and prophethood, which to Buddhists is anathema. To them a Buddha is a fully enlightened man, in other words a selfless being. Bahá'u'lláh states that no man can become a manifestation of God except by the grace of God. He constantly writes that we are all potentially filled with God; the Buddhist says this is a certainty in timeless time. What can exist outside God? Without His seeing eye how can we see ourselves or Him?

So great is the liberty of God that this apparently dualistic environment of life is the testing ground of our worthiness to return to his non-dualistic Heaven. In fact, as every Buddhist knows, Heaven is half-hidden behind any leaf, or stone, or human face, or even artefact. To us, his followers, Bahá'u'lláh was the predicted return, not of the Jesus, but of the Christ, or the Buddha, or any prophet-founder, reiterating the real and immediately relevant meanings of Life in our so-confused day. This realization came to me, not by any systematic study, nor even through the friendship of outstanding Christians or Buddhists, but by the quality of inspired selflessness in the lives of three Persians of our time: the Báb (the Gate), Bahá'u'lláh (the founder) and his son, 'Abdu'l-Bahá (the

interpreter and exemplar).* Bahá'u'lláh founded the Bahá'í Faith, which recognizes the essential unity of all the inspired religions. The paths are many, but the mountain of God has now been revealed as the bed-rock of world society.

During the First World War I privately published in Tokyo a booklet in which was written, 'I have seen a vision of the marriage of East and West, and far off down the Halls of Time I heard the echo of a child-like Voice. How long, how long? How I have longed for men of genius to come out of Europe instead of the average man of commerce, of statecraft and of churchcraft. The books which remain to be written, first and foremost, and greatest, *The Bible of East and West* ... greater than Blake's *Marriage of Heaven and Hell*; a love-union of the two hemispheres; a mystic ring on the finger of the world.'

I cannot say whence this vision came except as a ripple in the subconscious from the prophet or manifestation of God whom I now believe Bahá'u'lláh to have been. His writings *are* the first Bible of East and West.

The Bahá'í Faith with its principles of independent investigation, its unity, its roots in justice, universal education, balance of religion and science, marriage of East and West, recognition of art, of the equality of men and women, the need of a common language, the abolition of both great wealth and of great poverty, and, to these ends, of a universal parliament of man, has been laid out in detail by its founder. The structure is there and it has begun to function. It comes at the time of greatest need, when we are faced wth alternatives of unity or destruction.

This preface is not the place in which to expound on religion in any detail, but I feel it would be misleading and less than open and honest to avoid all mention of that Faith which is inherent in my thoughts whether written, drawn, or tucked away in the background of my pots. In whatever field of truth and beauty expression is sought, ultimately it appears to be a bridging of gaps between people and things, and of love between people and people; a

*On whom the British Government bestowed a knighthood (K.B.E.) in 1920 for humanitarian work in Palestine.

12

discovery of Totality enveloping the minor self. To every artist I would say that to produce anything of truth and beauty is to receive an invitation to heaven on earth, even in one's tatters. If man at this first time in which he holds the power of self-destruction in his grasp, chooses his identity with Life Itself, he attains what Bahá'u'lláh calls his maturity.

Oriental hearts are moved by 'nature as she is', or 'thusness', 'emptiness' and 'non-duality', or by such an untranslatable adjective as 'shibui', which nonetheless is understood by all Japan as the criterion of 'truth and beauty' and is her special gift to mankind. Those people of the Far East speak of brush, paper and ink as *The Three Friends*. As an artist how could I resist them? As a seeker after truth how could I remain silent about my search?

To those readers who feel surprised that I give such loyalty to three Persian Teachers whose spiritual and practical lives were selfless as was Christ's, my reply is that the absence of the separating self implies the presence of God. Those pure Mirrors reflecting that Essence of Being described in the Bible as 'I am that I am' I have called spiritual or divine geniuses of the human race. Jesus the Christ spoke many times of his return at 'the time of the end, the time of the Father'. All great prophets foretold their successors. Here then is

the link between East and West, and here too, hope for the unity of mankind.

The eye of God opened on the world in the middle of the nineteenth century as Bahá'u'lláh lay deep underground in the foulest dungeon in Teheran with iron chains and filth eating into his flesh and his companions being taken away daily to torture and death. He described this experience as the breeze of God blowing over him teaching him all things.

Bahá'u'lláh gave warning that the world needs a spiritual core: spirit over matter – not matter over spirit. A spirit with which to release love, understanding and justice, bringing about the maturity of man, an end to war and, for the first time, peace on earth. His is the Voice of God standing on the footprints of Christ between the polarities of the earth:

O Son of Man!

Veiled in My immemorial being and in the
ancient eternity of My essence, I knew My love for thee;
therefore I created thee, have engraved on thee Mine image
and revealed to thee My beauty.

O Son of Man!

I loved thy creation, hence I created thee.
Wherefore, do thou love Me, that I may name thy name
and fill thy soul with the spirit of life.

O Son of Being!

Love Me, that I may love thee.
If thou lovest Me not, My love can in no wise reach thee.
Know this, O servant.

O Son of Man!

If thou lovest Me, turn away from thyself;
and if thou seekest My pleasure, regard not thine own;
that thou mayest die in Me and I may eternally
live in thee. *

*From *The Hidden Words of Bahá'u'lláh,* London, Oneworld Publications, 1986

APRIL DAWN

Out of calm night,
Over hushed fields,
Wrapped in grey shroudings,
Cold clammy mists,
Rises the light.

Crossing broad heaven
With footsteps so light
That birds alone waken
To welcome the sight
Gladly in song.

From the long valley
Rise the grey mists,
Float the sweet sounds,
Fades the long night,
Heralding day.

1907

The Little hills *Etching* 1908

DEAD LONDON

Oh Londoner! walk thy streets,
Mile upon weary mile,
The long day through.
Let never dog bark,
Or bright eye greet thee
From Wapping Stairs
To Hampstead on the Hill:
No life upon the street,
No warmth in any home,
But death on every hand.
No bustle on the 'Change,
No echo in St. Pauls,
Silence and death,
Naught but thine own lone steps
And beating of one heart
That cannot stay its fearful throb,
Intolerable pain!
Yet half the truth alone is this,
– Only the toll of the dead.

On reading that the dead and permanently disabled by the great war amounted to over
twenty millions. Dec. 1915

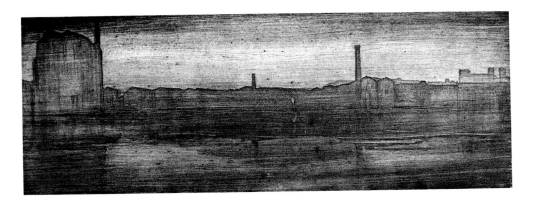

Night on the Thames *Soft-ground etching* 1908

COFFIN OF ENGLAND

England, my England,
Unconsciously you sleep
Upon a single board,
The top and sides are gone.
You failed to give,
So now they take
Ireland and India and Germany.

Oh John Bull
Your head does rest
Upon a bag of gold,
And Mr. Norman
To his foreman,
Well may say,
Take one away.

Beware, beware!
The end is near,
The wind is at the door.
And it will blow
And you must know
That when the others
Come to see John Bull
There will be naught
But dust upon the floor.

1915

My son, David *Pen drawing* 1914

SUMMER JOY

Deep in my heart
There flows a stream
Of melody.
Out of the garden
There grows a tree
Laden with flowers
For honey bees
In happy hours.

Sunshine and shadows
On stems of trees,
Leaves all a-quiver
In silent breeze,
Hearts are uplifted
High above these
In ecstasies.

1919

Woman's head and shoulders *Pen drawing* 1914

THE MYSTIC RING

Who will put
A mystic ring
On the finger of the world?

Who will keep
The flags of war
Perpetually furled?

Who will dance
And who will sing
To that great audience?

Who will wake
The ghostly flame
In each naked hand?

And make the earth
A ring of light
In God's long night?

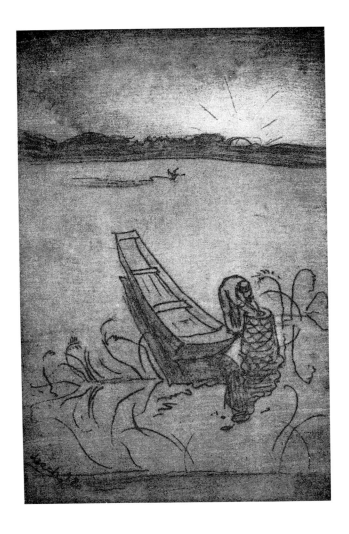

Abiko Lagoon *Soft-ground etching* 1918

ROMNEY MARSH

Sheep are nibbling the grass
On Romney Marsh,
Would I had a pillow
On Romney Marsh
Where flat winds blow through willow.
Love's door is shut on Christmas Day,
My heart is full on Christmas Day
Of what has been, great seas between.

1953

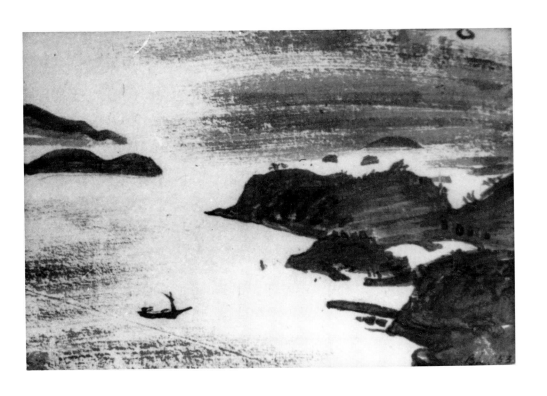

Japanese fisherman, inland sea *Brush drawing* 1935

MARABY

I rode upon a golden horse
Through the dun sands of Araby,
And in all that land
There was no horse like Maraby.

The white of his eye
At the prick of a lance
When his haunches rose
In the wars of France!

Where art thou now
My golden steed?
I am old, I ride no more,
Now I am back in Normandy.

Japan, 1955

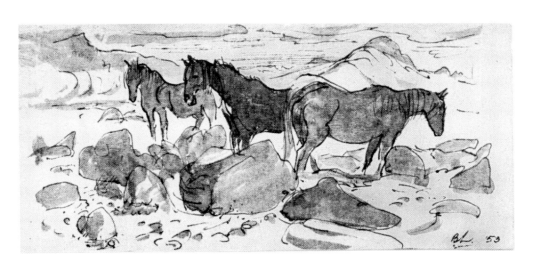

Horses in the mountains, Japan *Pen and wash* 1953

THIS CLAY

This earth upon which we stand:
Of which we are made:
Of which we make pots;
This volcanic rock,
Eroded, exploded – ashes to ashes.
Earth quivers in Japan,
Shaken by internal fires.
It grows bamboo shoots,
A foot a day –
June sends them up roof high.
In Cornwall we live on ancient granite rock
Standing against Atlantic surges,
Feet firm upon a ground that grows no trees
Whilst all winds blow.
Northern clouds roll
Over a rolling sea
And wrap our granite hills in mist,
Grass grows green throughout the year,
And spring comes stepping tenderly
With flowers along our rocky paths.
When I go back
Memories will wake with me at dawn
Of waters running fast
From mountains to the sea.
I shall see the maple burn
Upon the slopes,
And the cherry fall, in dreams.
My friends, no doubt,
Will talk of me, but I shall not go out
At night and feast with them
On beans and fish,
On buckwheat and on flesh.

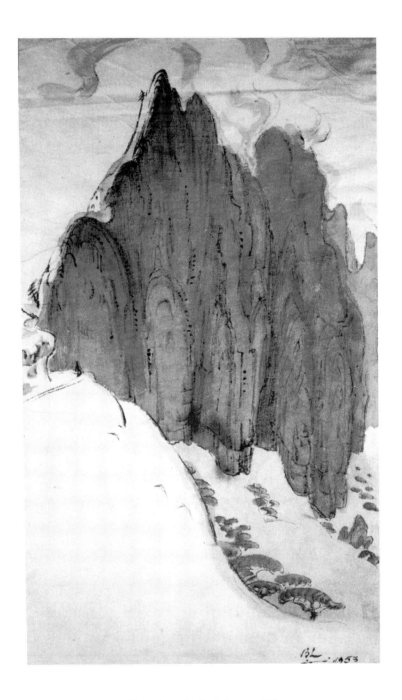

Volcanic peaks *Brush drawing* 1953

The wonder of the rice fields
On all flat land
From coast to coast:
Women in spotted indigo
Bending over the earth,
Tending it with love
As if it were a child:
Anxious old farmers peering
At their crops early in the morning,
Or as night falls.
Blue smoke rising to the mists
Which wreath among the pine clad hills:
Twinkle of silver bird-scares
Hung across the ripening grain:
Voices of semi (cicadae) and of frogs –
Frogs in the mud.
Clay spinning on a potter's wheel,
Clay spinning on wheels
All over Japan:
Clay in man, clay on the wheel
Spinning like the earth and the stars,
Man spinning the clay into stars.
Life spinning the man – LIFE.

Japan, 1962

Design for a pot *Brush and stencil* 1963

JAPANESE HARVEST

Harvest rich, rice
Yellow in the husk
Hung on trestles
All over Japan.

Sight for sore eyes
This largesse,
Daily food
For millions
From the valleys of Japan:
One in seven
Of these volcanic
Mountain isles.

Now too
Red persimmons
Hang on branches bare
All over Japan.

1964

Rice harvest, Japan *Pen and wash* 1953

We burrow through
The Alpine core,
Waterfalls, like
White blades, flash
Against the heights:
Dorsal roofs
Of old Japan
Steeper than
The roofs of man,
The plotted fields below
Are dwarfed to postage stamps.

From crest to crest above
Is spun a web of ingenuity:
Power cables strung
From damned-up lakes
To feed the cogs and wheels
Of city man.
How bland and sweet
The little hills of England seem.

1964

The village of Johanna, Japan *Pen and wash* 1954

BARNALOFT

My room so warm,
My window large,
At the sea edge.
The dried foam
Blows
Along the sand,
Rolls
Into nothingness.
Waves
Burst upon the rocks
Which stream
Like waterfalls.
Sea birds
Balance in the wind
Then streak across
My window pane.
The seventh wave
Comes rolling in
Right to the wall below.
At Clodgy Point
Under the north-west wind
Atlantic rollers burst
Full forty foot.

1965

Atlantic rocks *Pencil and wash* 1937

PORTHMEOR

The white barred sea
Invades our beach,
Advance and retreat.
Churning ships
Plough round our point.
The early sun
Strikes full upon
The granite wall,
Just above my window-sill.
Green the grass
On Chapel hill.

1965

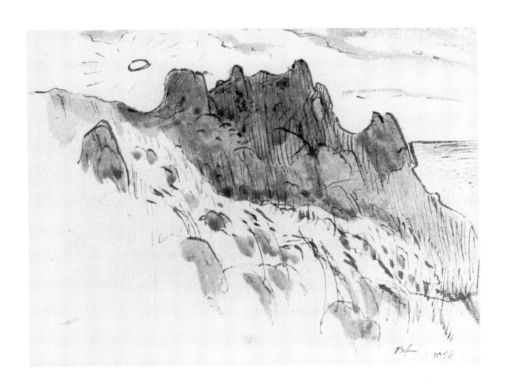

North coast of West Penwith *Pen and wash* 1956

THE WAVE

It stood up on end
And said:
'Lazy bones
And head,
Come out and play,
Come forth and dance.'
It waved,
I waved,
Everything waved.

1965

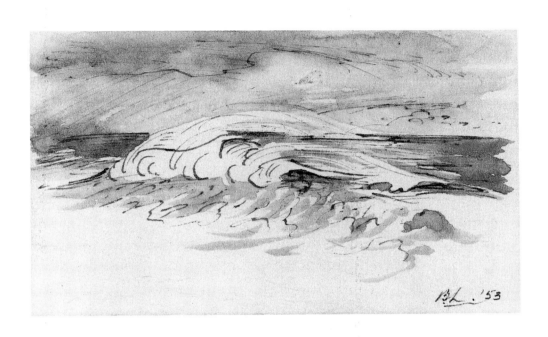

Running wave, Japan *Pen and wash* 1953

A PRAYER

Oh Lord my God!
How can I
Cry out to Thee?
That Whole,
This little me,
Wer't not
That in this me
A hint,
A spark,
A distant
Finger-print of Thee
Did here abide.
Oh Lord,
Sit down
With me beside.

1965

Sleep in the hills *Brush drawing* 1918

THE LAST ICE AGE

'*Nothing* changes'
Change never ceases,
Paradox on paradox.
Crawling out of the caves
Into fertile plains
After the Ice Age.
Have we forgotten
The long hibernation
In the dark?
Did we build Pyramids
Over our buried memories,
Before we stood naked
On Aegean islands
In the Mediterranean Sun?
For the first time,
We, free, and fearless.
Have we forgotten?

Nothing changes?
From the time of the
Ape and the mastodon?
Now that we begin to
Share and understand
The history of man,
And to probe beyond
The confines of this earth
Can we any longer say 'Nothing changes?'

1965

Swallow and young *Reed pen* 1934

OUT OF THE CAVERN OF MY EYE

Out of the cavern of my eye
I looked into infinity,
And in that no-mans-land
I laid my body down,
Heaven above, earth below;
No time, nor place,
No sun, nor moon,
Thy work is done,
I see Thy face,
I and my love are one.

1965

48

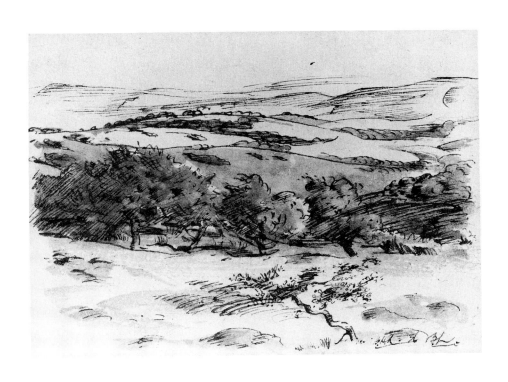

On the South Downs *Pen and Wash* 1936

ST. IVES CEMETERY

The dead lie quiet
On the hill
Facing the open spaces.
No wind blows through
The hair on their faces
Under the sod,
Under the sea.
They are not there
In those places
Where the body
Goes down to decay,
But oh how sweet
The wind on the heath.

1965

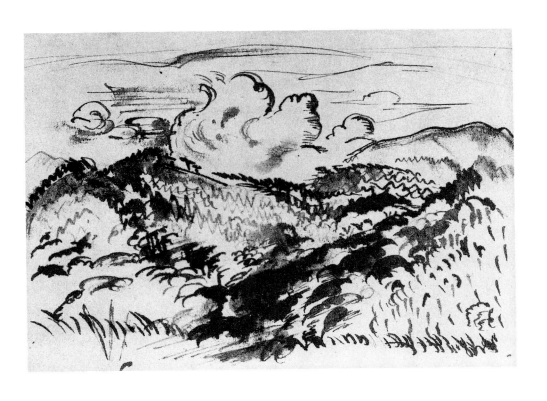

An eddy in the Japanese hills *Pen and wash* 1915

CERTITUDE

Thou Essence of all Being
I claim Thy Fatherhood in me.
Without Thy borrowed eye
How could I see?

1965

ST. IVES

On peaks and ridges
Of our roofs
A solitary gull.
Who could sell
That cry?

1965

Seagull *Brush drawing* 1964

EVENFALL

My picture window
Gazes at the sun
As it goes down
At evenfall.

A dark white wave
Came lapping
At my wall
At evenfall.

Surge and resurge,
A resurrection of the world
When I return from work
At evenfall.

1966

Californian sea-birds *Brush drawing* 1952

JAPANESE MOUNTAINS

Standing
Upon this pin-point
Of time and place
I watch the waters
Run to the sea,
And the mountains
Climb to Heaven.
The waves of the sea
Dance before the mountains
And they before God.

1966

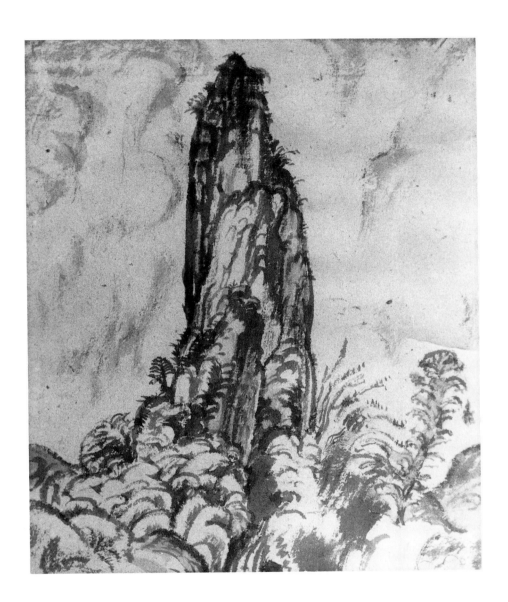

Pinnacle rock, Karuizawa *Brush drawing* 1918

BOSIGRAN

The couch grass
Trembles at my side,
The west wind blows.
Gull and northern diver
Wing the deep.
Lichen on grey rocks,
Bracken on the slopes,
One carefree marguerite,
The air so keen.
The days have gone and passed, my love,
That you and I have seen.

1966

Two cormorants *Brush drawing* 1973

SAND IN THE EYE

Overhead the sun,
Beyond, the galaxies
Ad infinitum.
Which means
That all that man
Can reach
Is but as
A grain of sand
Upon this beach.

1966

Sand dunes, Japan *Pen and wash* 1953

THE INFINITE INCH

When one inch
Does meet a mile
It meets infinity.
You smile.
But when infinity
Meets an inch,
You flinch!
Maybe
It smiles.

1966

Beggar and songbird *Etching* 1910

PREMONITION

Old age
Trod upon my toe
Last night.
Stumbling
Up the lane
I saw a light
And entered in;
Of blackberries
I laid a bowl
Before my friend,
Wiping my glasses
Before his fire.
'Keep them for this respite
On this premonitory night.'

1967

On Ditchling Beacon I *Pen and wash* 1936

MY CHRISTMAS TREE

Do I seek an end
To anything
That God
May send
Whether of joy
Or any pain?
Here in myself
I know the price
To pay
From day to day.
Oh! sweet pain,
That I might
Light my candle
At Thy Christmas Tree.

Christmas 1967

On Ditchling Beacon II (The same landscape as No. I) *Pen and wash* 1936

YIN, YANG

Yin, Yang.
Day and night,
Sun and moon,
Land and sea,
Me and the not me.
Perhaps the Lord
His work to see
Smiles in eternity.
But here and now
We laugh and cry
Torn between duality.
Oh God!
To find the meeting place
Once more
In Thee.

1967

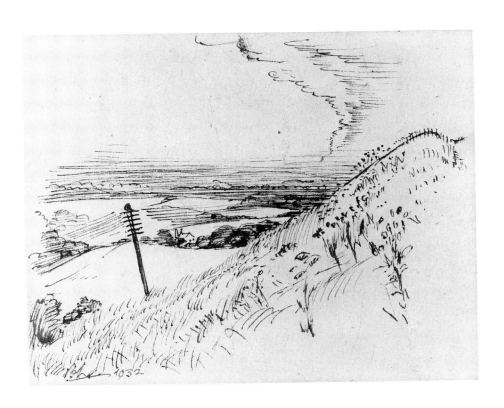

On Ditchling Beacon III *Pen and wash* 1932

THY TOY

With every wriggling pride
Thou smitest me.
Oh let me take
Thy stripes with joy,
For Thou art me
And I Thy toy.

1968

ETERNAL MOMENT

All that has been
Is now,
All that shall be
Is now,
In this seed moment.

1967

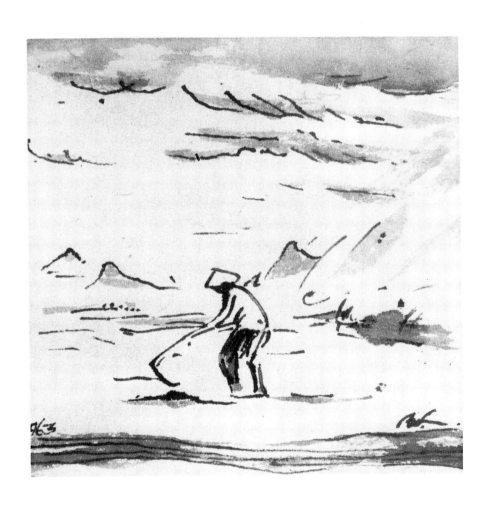

Japanese farmer tilling *Pen and wash* 1963

THIRST

A lion lies
With cat's paws
Stretched
Along the ground
Awaiting the dawn wind
When deer
Come down
To drink
And he
Can slake
His thirst.

1968

Deer at night *Tile* 1971

JOURNEY BY TRAIN IN JAPAN

Pale green bamboo fronds
And burning maples
Against the dark green
Cryptomeric slopes.
Strong bones
Of mountain mass.
Chrystalized plasma
Of this volcanic core,
Tumbled, triangulated.
Ravined waters
Running fast,
As hungry for the sea
As any salmon
For the quiet pools upstream.

1968

Bamboo thicket and rice paddies, Japan *Pen and wash* 1953

LEAVES

Your leaf,
My leaf.
All leaves
Under the sun
Whispering,
Making shade.
All different,
One side up,
One side down.
The Wind-Lord came
And danced them
Downside up.

1968

Karuizawa, heavy drops of rain *Brush drawing* 1917

TEA-LEAVES

You stirred the tea-leaves
Before you left last night.
Through the dark hours
They would not settle;
I could not sleep.

1968

A Japanese friend *Pen and wash* 1911

BUDDHIST CIRCLE

No before
Or after:
A circle
Without bound,
The centre
Everywhere.

1968

Japanese woman farmer transplanting rice *Brush drawing* 1953

STRANGE MYSTERY

Strange mystery
Your soul and mine
Have touched in eternity
Have I indeed
Lit your torch?
For in that placeless place
There is no yours and mine.

1968

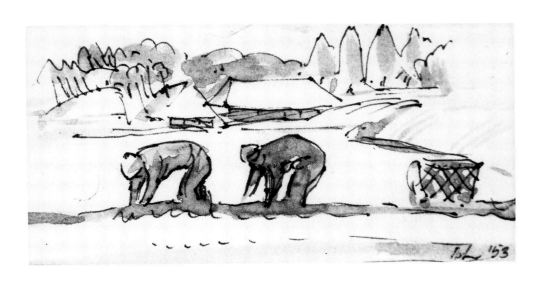

Rice planters, Japan *Pen and wash* 1953

FOR EVER AND FOR EVER

Each shining face
Of sea, lake and pool
Of all this earth
Reflects the face of Heaven.
Each facet of mica
Locked in the granite
Mountains of the world
Awaits its turn;
An end to space
Cannot be thought.
The stars so brilliant
Shine for ever and for ever.

1968

Dew pond *Pen and wash* 1935

MATHEMATICAL EVIDENCE

Without the one,
No two or three
Or multiplicity,
Division or subtraction.
Q.E.D.

1969

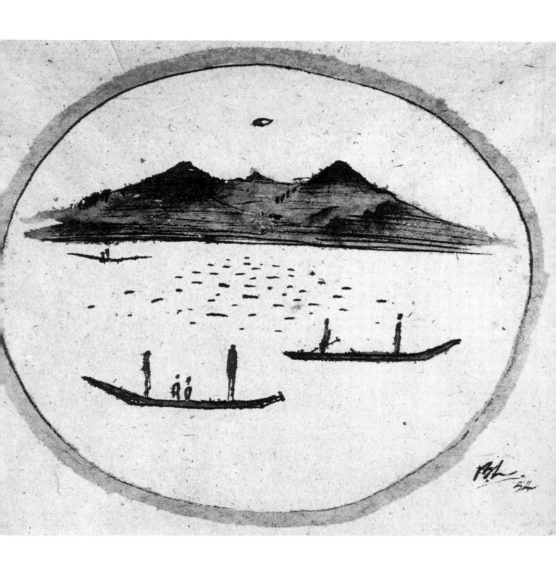

Plate design: Fishermen, inland sea *Pen and wash* 1954

MY GREEN MOUNTAINS

Tiger-lilies grow
On my green mountains.
Winds blow
Over the crests,
Down the flanks,
Hither and thither.
Cat's-paw play
In silvered grass
On those green mountains
Far away.

1969

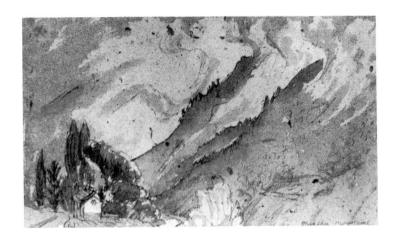

Up a side valley, Japanese Alps *Pen and wash* 1953

I HAVE NO DOUBT 'SOEVER

I have no doubt 'soever
But that
He, the Giver,
Of hill and river,
Of every life a-quiver,
Planned it so
That at a given point
Knowledge of good and evil
Would arise as it did in Eden.
And man, or his better,
Would choose both
As he has ever.
But to end there,
As is the fashion now,
No beginning, no meaning, no end,
Is as the utmost
Trough between waves.
Arise! Arise! The Word is out,
God is about,
Not alone in Heaven
But here and now even,
Hell too for that matter –
Our making or choosing.
We may even find God
Our home and our Heaven.

1969

The valley of Matsumoto *Pen and wash* 1964

IN GRATITUDE

Oh, let me out
Into the garden there
I want to put down
My shrunken hand
To the green grass
Yet once again
Before I lie quiet
Under the sod.
Many voices rose gently
To Him the Lord God
Who looked down in mercy
And said 'Spare the rod'.
In this room
Where I have known
Such pain and joy
I felt the tremor
Of those prayers
All the way from
Here to Carmel.
Oh God wilt Thou
Accept my thanks
From here to Heaven?

1969

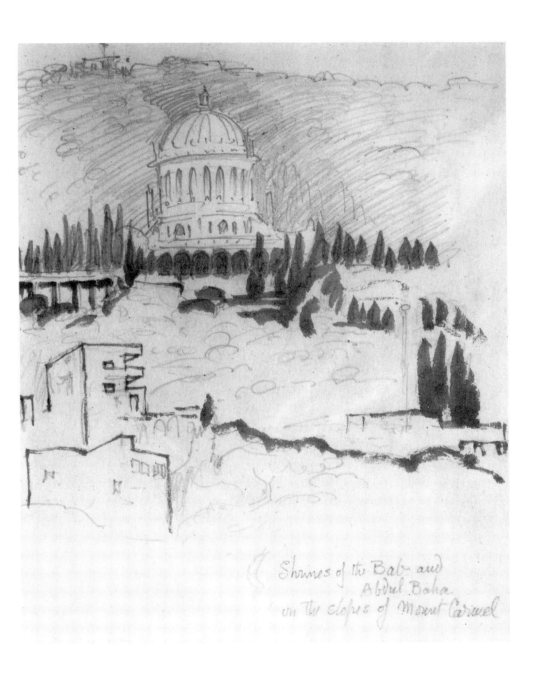

Shrines of the Báb and
Abdul Baha.
on the slopes of Mount Carmel

The Shrine of the Báb, Mount Carmel, Israel *Pencil drawing* 1969

DAWN

Dawn crept across the lawn,
I never saw such pristine light before.
A cock crew,
Pigeons crooned.
From my bed of sickness,
In blanket wrapped
I put my head forth
And saw the sun rise,
Walking like God
In the Garden of Eden.

1969

Shinji Lake *Pen and wash* 1953

THOUGHTS

Thoughts go floating on
Dissipated in space
Don't kid yourself
Into thinking either
That, like brief candles
They are blown out.
Or, that they remain
Your precious property.
They wander,
Like interstellar gasses
Or like microscopic agglomerates
In the blood:
One, in some sense,
Yours, no doubt,
Now beyond time and space,
Yet susceptible
To the butterfly net
Of some sensitive mind
Who will doubtless
Pin them as trophies
In his collection
Draped round some theories
He thinks his own
Yet his may prove
A brighter mind than yours.

1969

Hong Kong harbour entry *Pen and wash* 1934

THE CHOICE

My beginning was in God,
My journey's end is in God.
He in His magnificence
Gave me choice.
So often I choose myself before Him.

This then would seem to be
The way in which
God can see Himself,
And my way would seem to be,
For my own salvation,
To end this dualism.

Thou art the inescapable All.
Thou embracest all things,
Including me, foul me,
Who have so often disregarded Thee.
I would it were not so,
But so it is,
Thou gav'st me choice,
To be or not to be.

1969

Book cover *Pen* 1918

THOU IN ME

In eternity
There can be naught
But Thee.
Thou gav'st me choice
And I in frailty
Failed Thee,
Again, again.
I look me down,
I look Thee up
Where Thou art not,
And yet Thou art as well.
Strange mystery.
So when I err
And thereby understand
Full well,
There is no me, nor Thee.
Oh lend a tender hand
Oh Thou in me.

1970

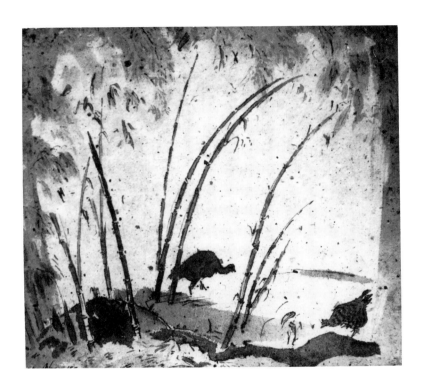

Turkey and hen under bamboos *Pen and wash* 1935

WINTER'S AXE

Come all ye flowers
After long summer's hours
Bend your slim necks
To winter's axe.

Ice may wither,
But your roots never.
By nature's powers
In next year's spring
Spread your leaves,
And then your flowers,
Reappear with fruit and seed,
Pay then your winter's tax.

1970

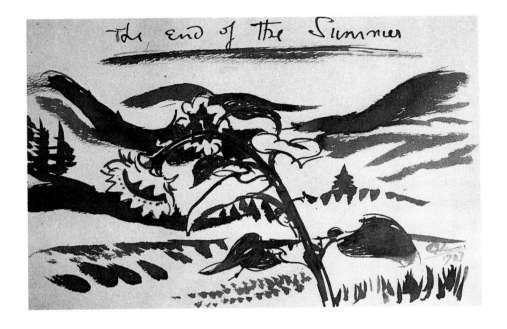

The end of summer *Pen and brush* 1917

PENNY PLAIN, TWOPENNY COLOURED

If a pot does not speak
What can a potter say?
Yet was I given words
As well as clay,
So let me claim
The best pots ever as humble
And the rest are free of pride.

1970

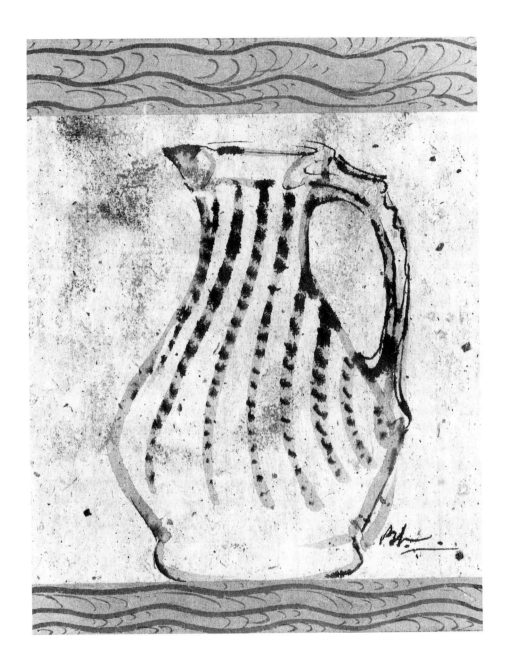

Jug design *Pen, brush and ink* 1957

THY STRONG BEAMS

Sun, sun
Run your purple races,
Barred with gold,
Across flat fields.
Each blue shadow
Of standing elms
Pointing to oncoming night.

Sun, sun
Run not thou so fast
Across thy fields
Casting glooms
Behind thee.
For thy strong beams
Uphold me,
And I in them
Would warm my heart again.

1932-70

Japanese rice fields *Pen and wash* 1964

HER REPLY TO HIS PROPOSAL

'Oh dear, Oh God!
Oh Lord my love to see
Stepping o'er the grass to me',
'Shall we married be?'

In Heaven
There is no giving
They say,
So he who speaks to me,
In truth, must be
Of earth.

And yet,
I thought
Of Heaven too.
'Oh yes, my love,
I'll marry you.'

1970

Hamada strolling *Pencil and wash* 1954 Kawai strolling

BURNING STARS OF NIGHT

Burning stars of night
Are you indeed more bright
Than he who shines
Over my shoulder
Across the lawn
This very morn?
Dew on the grass
Our sun in every bead?
Doubtless some are Elder Brothers
And some dead in empty spaces.
How do they dance,
In couples even?
In vast whorls of giration,
Some bursting into light incredible,
But there before our eyes, invincible!

1970

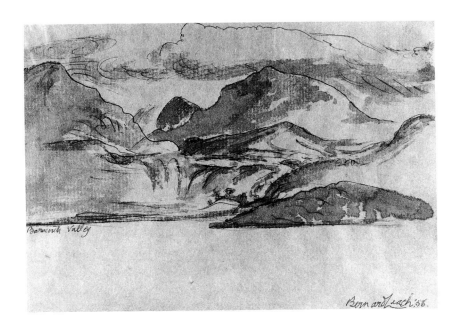

Barmouth valley, Wales *Pen and wash* 1956

THE THIRD PATH

Sixty-six years since my father died,
My mother gave her life for mine
When I was born.
Oh, did you two
Stand by my bed this night
And point me to
A pathless path?
I awoke this very morn at six
And greeted you
With all my love.

1970

112

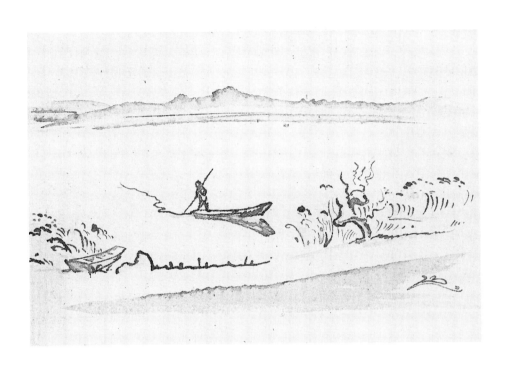

A punt, Abiko Lagoon *Pen and wash* 1918

EVERLASTING BLOOMS

No need to cut
The living stems
To send flowers
To the dead.
I have seen blooms in bowers,
Yellow centred
On the walls
Of timeless time:
Petals of blue and white;
Those golden-hearted blooms
Endlessly on every half-toned wall;
The essence of all flowers
Within a narrow scale.

1971

Book cover: Evening primrose *Brush drawing*

TO STEIVE

Cut away
The thorns
The briar,
Forget carns,
Grow wings,
Your own,
Fly higher,
Life Itself
Contains
High and low.
Fly low,
Fly high,
Fly free!

1971

Young kingfisher *Pen and wash* 1934

TRANSMUTATION

When by sin
I am furthest
From my Lord
He is nearest me,
His feet so close behind.
Thus, by contrast,
Does He know Himself.
Can there be light
Without a shade
In this our world?
He made us
'In His own likeness'
It is written,
Hence direct knowing,
A click of certitude
Which states
'I know that I know'.
It shouts in the shell
Of my ear,
It is silent
In the heart
Of a stone,
It bleats;
Not the lamb,
Nor yet the ewe,
But that which is the Whole 'I am'.

1971

Fish *Brush drawing* 1960

THE GREAT OAK

It was not by evidence
Or comparison
That I sensed
Truth and beauty
As aspects
Of one Whole:
They are as parts
Of a great Oak,
So blent and interweft
Of root and trunk,
Branch, twig, acorn,
Or good brown leaf –
Or green – fresh fed
With earth's clear juice
Sucked up by those deep roots;
Changed, fountained in the ambient air
Yet once again.

1971

Little oak *Etching* 1910

MY LITTLE FINGER

Even as I cherish and bind
My small cut finger, thus,
Oh God have mercy on mankind,
Have mercy upon us,
We and Thy stars,
The firmament
Are Thine.

1971

Japanese Alps *Pen and wash* 1963

VENUS ON THE WAVE

Standing on the edge
We watched the sun go down,
One long last glance
And it was gone
And we alone.
Then saw I
Venus on the wave
She trembled there
And, slow, the company
Of all the stars.

1972

124

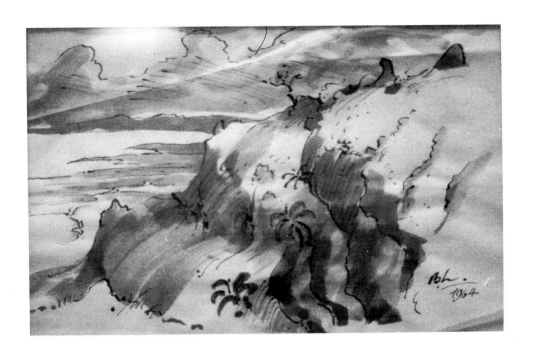

Okinawa coastline *Pen and wash* 1964

THERE

There we shall endure,
There we shall find quiet,
No letter will come,
No bell be rung,
There will be no need:
We shall be in mind free
With whomsoever, wheresoever
We wish to be.
For the past
Makes the present,
And we our future
In timeless time
And placeless place,
And we shall be
Both judge and jury,
Mind over matter,
In that everlasting now;
You in It, It in you
Forever and forever.
We shall see
As we never saw before,
We shall be
As we never were before.

1972

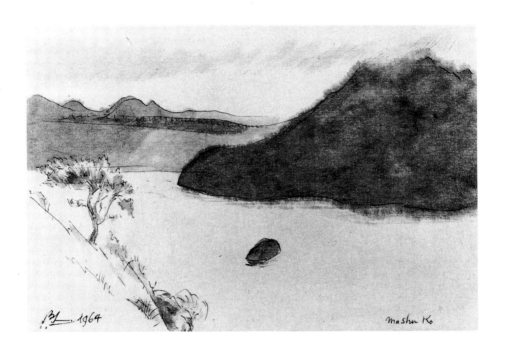

Crater Lake, Hokaido *Pen and wash* 1964

THE RAPIER OF LOVE

Age does not wither
Your beauty my dear,
It is not subject to the years,
Flying blythe on wings of spirit
Love, like a rapier,
Still stabs me to the heart.

1972

COME

Come today
Come to-morrow!
Come in joy
Come in pain
Or in sorrow
Come again;
To-morrow and to-morrow.

Christmas 1972

128

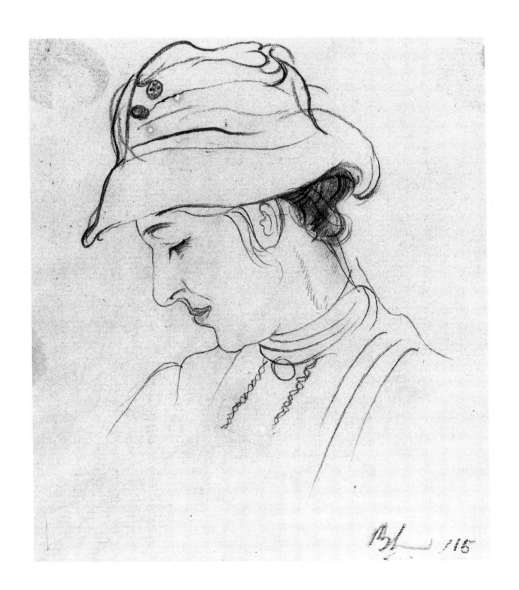

My wife, Muriel *Pencil drawing* 1915

WITH REVERENCE

Inscrutable God
Look down
From Thy Infinity
With love
On fallibility.
For it was
With Thine own
Spare rib
That Eve was made.

1972

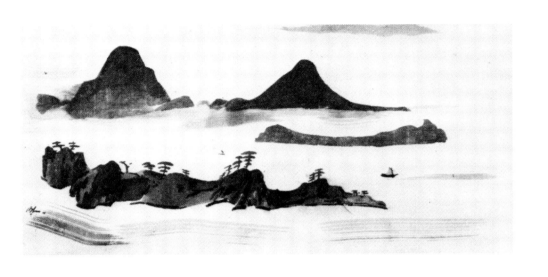

Inland sea, island *Brush drawing* 1953

THERE IS NO DEATH

If matter is deathless
So too is spirit.
Change, yes,
But neither emptiness
Nor death.
Quick make friends,
Make amends,
Before the last breath.

1972

Marble rocks in China *Lithograph* 1918

UNDER WHAT STAR

Life so kind
Under what star
Was I born?
Full forty friends
Have gone
And more remain.
A star shone
Over East and West,
Took me to new pastures
Where I sowed seeds.
I saw them grow,
Now I can go.

1972

St. Ives harbour *Pen*

THE MOON

Away up on high
A silver sixpence
Riding the blue races
Of the sky

The great orb
Of the golden moon
Kissing the cool brow
Of an August hill
Now.

1973

JAPANESE WATERFALLS

Waterfalls
Like blades
Flashing from scabbards
In the hidden hills.

1972

Horse and cart *Pen and wash* 1917

IN AETERNITATIS, COR

There is a Being
Of all beings
The heart and centre
In aeternitatis, cor.

We, in our bodies,
And in our minds, complete,
Dance with His firm
Yet playful feet,
In aeternitatis, cor.

In a broken stone
Or wayside flower
Find Him there,
Parent of all polarities, everywhere,
In aeternitatis, cor.

1973

Two shells *Brush drawing* 1954

O THOU WHO ART

Help me to endure
And to accept pain
To balance joy
Upon this our plane,
Or testing ground,
That in the further life
Beyond the gate of death
I may expand
Eternally in Thee.

1973

Pilgrim *Stencil and brush* 1968

DAPHNE GENKWAN

Around my porch
As dusk comes
The rare scent
Of the small purple flower
To greet my guests.
Subtle and sweet
It welcomes them
To green tea
And intimate converse.

1973

Minagawa, the last pattern-painter in Japan *Pen and wash* 1953

BLINDNESS

Come blindness
With the dawn this day.
Not to see a human face again.
Not to see a line on paper drawn.
Warning, yes, but both this day.
Groping along walls,
Premonitory steps.
Awake, awake, the inner eyes,
Love more, not less.
The memories of human sight,
See *with*, not *through*.

1973

Dr Soetse Yanagi *Pen and wash* 1918

TIGER, TIGER

Behind its bars
A tiger glares
From the forests of the night.
An angel stands beside that cat
Quite unafraid.
Night is with terror bound
And day with burning sun,
Yet is there a world between
At dawn and dusk,
Both seen and unseen.

1974
After William Blake

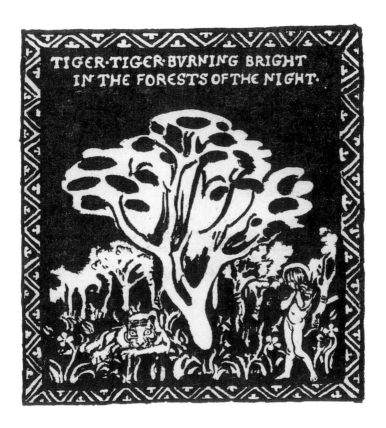

Tiger, Tiger *Woodblock* 1913

STEEPLE LANE

Friendly sounds of hoof on stone
Clippety-clop down Steeple Lane;
Dappled sunlight under elm leaves
Sitting by a five-barred gate;
Flowers everywhere
This dry year.
Bird talk all around –
A robin with young
Scolding a blackbird
In defensive rage:
A wood-pigeon purrs
From tree to tree;
A far-off cuckoo calls.
Foxes and badgers
In rhododendron woods
Round Steeple Hill.
Clippety-clop, over the top.

1976

Small wild birds *Pen and wash* 1935

TRANSLATED FROM THE JAPANESE

Lying awake at night
I heard the cold 'cheep'
Of autumn quail.
Tears of loneliness came.

From a classic of the tenth century

So un kuo

Ravine, Hokaido *Pen and wash* 1964

Those who seek fame and profit
Little know the peace of the hills.
Morning and evening the clear air blows,
Between heaven and earth my life exists,
My lungs expand, my body functions at ease,
If I think of other places, nowhere attracts,
If I think of this place, nowhere distracts.
The moon waxes full, the pure winds blow.

Ogata Kenzan (1663-1743, great-nephew of Koyetsu).
He wrote of his life in the hills outside Kyoto in 1699.

from Hofukaji Matsumoto BL. 1964

Looking over the valley of Matsumoto *Pen* 1964

TRANSLATED FROM THE JAPANESE

Cold fingers reach out
From the thickly frozen stream
To where I lie this night.
(Later)
Again ice on the stream,
I broke it from my pillow.

Ogata Kenzan (Feb. 1737)

Shikari Betsu, Crater Lake *Pen and wash* 1964

Listen, you world of insects,
That is the famous voice of the nightingale!

A fire-fly slept upon this leaf last night,
Keep off Big Feet!

Issa (1763-1827)

Moth *Pencil drawing* 1917

TRANSLATED FROM THE JAPANESE

Waking towards dawn
In a country inn.
The lonely wind
Combing the pines.

Honami Koyetsu (First artist-craftsman, 1558-1637)

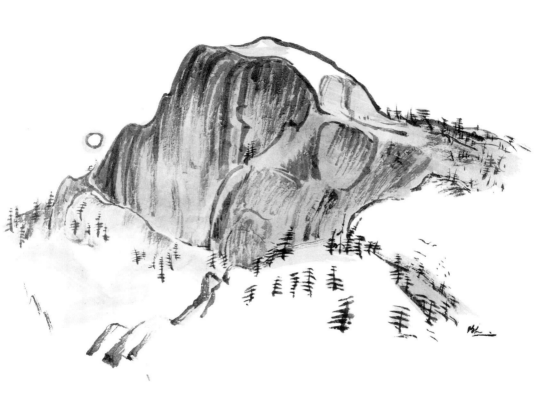

Yosemite Park in snow *Brush drawing* 1952

TRANSLATED FROM THE JAPANESE

When spring flows through
The paddy leats
We hunger for the sun.

Summer comes
And heats the water
For our daily bath.

Autumn maples
Burn upon the hills
And warm our hearts.

Comes winter once again
With ice
To roof our house.

First translation from a Japanese folk song, The Song of the Lampreys 1953

Japanese storage house *Pen and wash* 1954

TRANSLATED FROM THE JAPANESE

All people with grief
Beating each other and crying
When war came
Like hail over corn.
But the time will be
When the red sazanka*
Will bloom again,
Quietly, half hidden.
Fear not, that time
Will come again.

*The sazanka is a variety of camelia.

My old friend, the potter Kenkichi Tomimoto, who died in 1964, wrote this poem for me to express his feeling at the outbreak of the last war. He did not send it because he could not translate it. With help I translated it into English in 1947. Tomimoto and I both received the traditions which came down from the first Kenzan and his great-uncle Koyetsu.

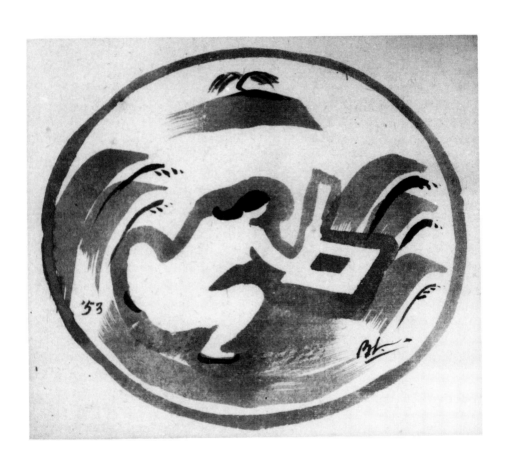

Korean washerwoman *Stencil and brush* 1953

Reflections

Deep in my heart
There flows a stream
Of melody.
Out of the garden
There grows a tree
Laden with flowers
For honey bees
In happy hours.

Sunshine and shadows
On stems of trees,
Leaves all a-quiver
In silent breeze,
Hearts are uplifted
High above these
In ecstasies.

This was written a long time ago. It must have been before we came back from the Orient in 1920. 'Hearts are uplifted high above these in ecstasies.' Does anybody know the meaning of those moments in life? I think they are the most precious, because they point to the essence of life's meaning, and that is being shaken now, all over the world, with its uncertainties – very often not expressed – about the future of man.

Oh Lord my God!
How can I
Cry out to Thee?
That Whole,
This little me,
Wer't not
That in this me
A hint,
A spark,

A distant
Finger-print of Thee
Did here abide.
Oh Lord,
Sit down
With me beside.

I think this was the first attempt I ever made to put rhyme or rhythm round a religious approach. I think in my heart I call this a child's prayer, but it is my prayer also. What should I say about it? Yes, I do pray; I do believe in God. I do believe in all the aspirations of man towards that essence of being, which I would like to call the Master of all Infinities.

Overhead the sun,
Beyond, the galaxies
Ad infinitum.
Which means
That all that man
Can reach
Is but as
A grain of sand
Upon this beach.

I live next to a beach – right over it in fact. The high waves of high tides come against the walls below me. Porthmeor Beach in St. Ives, Cornwall. The sun goes down to the West and I watch it, not merely as it goes downward, or seems to go downward, but also, as the months change, it goes inland as Winter comes on, or Autumn; it goes a long way inland and you have to wait until late in the Spring before it begins to leap down, to go down beyond the land, to go to sea again as it were. For an old man – I'm close on ninety – that vision of the sun's going down in the West is a great inspiration, an introduction to life that one sees, after those long years, in perspective, I think – a little wiser, better, clearer in the distance than formerly. One wants to know, and I believe it is possible for man to know truth when he runs into truth. And death – or 'the gateway', I would rather call it – lies before us all, and before the last understanding in the flesh we would like to know the meaning, and know that we know, and this I believe is possible for all mankind.

Yin, Yang.
Day and night,
Sun and moon,
Land and sea,
Me and the not me.
Perhaps the Lord
His work to see
Smiles in eternity.
But here and now
We laugh and cry
Torn between duality.
Oh God!
To find the meeting place
Once more
In Thee.

What more can I say? I hope there are many people who still believe this. 'Yin, Yang' – the 'yes' and the 'no' of all things. This is the special Chinese ancient way of looking at life's meaning. We are still looking at the same choice between 'yes' and 'no' – that is the freedom that God is so generous in giving us, and not taking revenge upon His own creation. Surely He must understand both always, or He would not be, as I have called Him, the Master of Infinities.

My beginning was in God,
My journey's end is in God.
He in His magnificence
Gave me choice.
So often I choose myself before Him.

This then would seem to be
The way in which
God can see Himself,
And my way would seem to be,
For my own salvation,
To end this dualism.

Thou art the inescapable All.
Thou embracest all things,
Including me, foul me,
Who have so often disregarded Thee.
I would it were not so,
But so it is,
Thou gav'st me choice,
To be or not to be.

These poems follow along a line of thought, the 'meaning of life'. Man needs humility. He has got to get rid of himself, his egotistic self, because that is the source of duality. And yet our Western way of thinking about life has been merely, in its latter part at least – let us say from the time, perhaps, of Leonardo – one of duality, of rationality, of intellect over imagination, intuition, inspiration. Now I am an artist of some kind, and I know, and I must know and I cannot help knowing, that it is the other way on, that in effect imagination was the great thing that we were given as our most sensitive tentacle to the meaning of life. What did Blake write? 'What is now proved was once only imagined'.

Even as I cherish and bind
My small cut finger, thus,
Oh God have mercy on mankind,
Have mercy upon us,
We and Thy stars,
The firmament
Are Thine.

I was brought up in the Roman Catholic Church. I went to an art school, the Slade, at the age of sixteen and began to try to think for myself. And I ran into Omar Khayyam, translated by Fitzgerald, and it began to make me ask primary questions. Hell, heaven, purgatory – hell is the hardest. What Bahá'u'lláh, a prophet of our time, in my life, said was, 'Love Me, that I may love thee. If thou lovest Me not, My love can in no wise reach thee. Know this, O servant'. That, in one way, explains the anger, the rejection of the poor, cut finger – you with yourself really. But we normally want to bind up that little finger, and that is where I think the meaning behind the word of condemnation really lies, because all evil is in a sense only the reverse of good. And it has

167

sometimes been said that the footsteps of the saviour are so close behind the sinner in his greatest sin.

> *If matter is deathless*
> *So too is spirit.*
> *Change, yes,*
> *But neither emptiness*
> *Nor death.*
> *Quick make friends,*
> *Make amends,*
> *Before the last breath.*

This I do feel very strongly; I do wish so many of my friends who are in doubt to believe, to love enough their fellow man, and through man God's creation and therefore God Himself, the essence of being. Do I fear death? No. I can say that having been fairly near indeed to death seven years ago, and two days after the specialist and my doctor said, 'We never thought you would get through, we don't know how you've got through'. I knew — I was lifted up by the prayers of many people, some of whom had never met me, in England, abroad, in Haifa where the centre of the Bahá'í Faith is. And I knew too that a great attempt still needed to be made, a statement about the meanings that I've seen in life, in my own life as a potter, as an artist, between two hemispheres, East and West, and that I would like to make that clear at any opportunity which came my way.

Bernard Leach

Based on an interview for 'Pause for Thought' on BBC South West Radio, 1976.